MW00774519

THE SHIT OF GOD

THE SHIT OF GOD

—Diamanda Galás—

New York · London

Library of Congress Catalog Card Number: 96-68814

A full catalogue record for this book can be obtained from the British Library on request

First published 1996 by
High Risk Books/Serpent's Tail
4 Blackstock Mews, London N4 2BT
and 180 Varick Street, 10th floor, New York, NY 10014

"Wild Women with Steaknives," "Malediction,"
"Let's Not Chat About Despair," "Double-Barrel Prayer,"
"Let My People Go," "Birds of Death," "You Must Be Certain of the Devil,"
"Judgement Day," Plague Mass, Vena Cava, Schrei X, *and* Insekta *published by Mute Song; administered by Winswept Pacific Entertainment Co. in the US and Canada*

"Panoptikon" *and* "Song From the Blood of Those Murdered" *published by Metalanguage (BMI)*

Text and cover design by Rex Ray
Printed in Finland by Werner Söderström Oy

"I'll make that guy happy; I'll jump in a hole and kill myself."

—J. Galás

ACKNOWLEDGEMENTS

✝

Diamanda Galás would like to gratefully acknowledge

the contributions of the of the following

individuals and groups:

Charlie Atlas, Stavros Christofi, Blaise Dupuy, Michael

Flanagan, Philip-Dimitri Galás and the Galás family,

Linda Greenberg, Chaz Harper, Byl Hensley,

Aldo Hernández, International Production Associates (IPA)

and its staff, Andrew King, Dan Kotlowitz,

Scott Mac Cauley, Barbara Maier, Daniel Miller,

Ira Silverberg, Serena Toubin, Bobbi Tsumagari,

Carl Valentino, Valeria Vasilevski,

Jed Wheeler, and Paul White

Contents

INTRODUCTION

HOW DO I BEGIN to characterize the work and vision
of Diamanda Galás? She is, without question, an
extraordinary artist. There is a purity of intent and
execution in her creations which lends them an
intensity which leaves this listener breathless, raptur-
ous, and perhaps a little intimidated. There are no
concessions to commercialism here; no softening of
the blows; no pandering. These are works made by
an artist who risks, perhaps even invites, horror and
repugnance in the process of making her mark on
our hearts.

She does not do so from some perverse hunger for
notoriety. The subjects she chooses to address are
profound and terrible, her response to them rage
and grief. Anyone who has heard her sing, especially
live, knows how extraordinary an experience it is to
share that unburdening; how her voice—ONE MOMENT

SERPENTINE, THE NEXT A JUGGERNAUT—carries her audience on a journey into primal regions, where intellectual analysis and even aesthetic judgments become redundant. All you can do is listen and feel.

As the words contained on the pages following go to prove, there is something medieval about Diamanda's worldview. We live, her art tells us, in a tormented space between sanctity and damnation, visiting cruelties upon one another even as cruelties are (APPARENTLY ARBITRARILY) visited upon us. Chief amongst those horrors, the plague which she has so powerfully addressed in her work. Desolation and despair are only a breath away, she reminds us, and raises her voice in spine-chilling howls to express our response for us. There is, to my way of thinking, a healing function in the release of that emotion; in hearing the rage and frustration transformed into something both beautiful and universal.

My personal dealings with Diamanda have been to date regrettably brief. I have been a fan of her work for some years (several of my more intense paintings were made with her voice for company), but it wasn't until I came to direct a movie called *Lord of Illusions*, and was in need of somebody to interpret a song for the end of the film, that we made contact. I doubted she would accept the gig. I was, after all, asking her to cover a classic, smoky song written decades before: "Dancing in the Dark;" very far from the work for which she was celebrated. But Diamanda is an iconoclast. Her only rule, it seems, is that there are no rules. Yes, she replied; she would be excited to

perform the song. We met after one of her shows, and discussed the project for a little time. Then I left her to perform her transformative magic.

When the tape from New York arrived, with her remarkable vocalization upon it, I was astonished. The song, which has been covered over the years by every major recording star, male and female, had not simply been transformed, it had been reinvented. It was chilling, it was touching, it was bitter-sweet, it was ecstatic. I must have played it a dozen times within an hour of its arrival at my offices, calling in everyone to hear the piece that would close our picture. I'm sure Diamanda has a healthy artist's contempt for critics, but a goodly number of the reviewers, when talking about *Lord of Illusions*, suggested audiences wait in their seats until the credits were done rolling, because there was still a great treat in store.

Let me now step aside, and let you have access to the work that follows. To the thunder and the lyricism of Diamanda's words, to their grandeur and delicacy. For those of you familiar with her performances, her voice will no doubt accompany you through this poetry, rising to a heavenly howl or plunging into infernal mutters as you go. For those of you who are not yet members of her tribe, these words will have an extraordinary intensity nonetheless; an intensity that will be multiplied a hundredfold when you hear the voice that carries them.

The landscape she conjures is not one most artists

would even attempt to map. Let's be grateful, then, that Diamanda's hunger for unexplored spaces, and her courage in the face of their desolation, has given us these unique records of those wastelands. And perhaps made it possible for the rest of us, more timid souls, to follow.

—*Clive Barker 1996; Los Angeles*

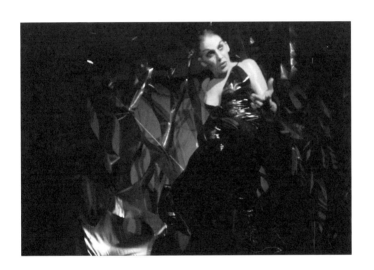

[*Photo: Will Gullette*]

A DISCUSSION CONCERNING THE COMPOSITION OF
Wild Women with Steaknives

This music is concerned with tendencies towards
 excessive behavior.

An obsession,
 extremes omnipresent and encroaching upon
 the other,
 within microseconds, coalescing one
 moment and dissolving the next,
 towards an ultimate dissolution,
 which is the soul's own Implosion.

You do not go to a hospital to inspire the recreation
 of your own
Death onstage. You know it by heart.
This need, this voracity for the extremes of
 consciousness I return to.
An actor may simulate the desired emotive state
 through a skilled
 manipulation of external object materials, or he
 may use the raw
 materials of his own soul in a process which is the
 immediate,the
 DIRECT experience of the emotion itself.

 This second concern is felt by performers who,
 not just professional,
 are *Obsessional* performers.

IN 1975 I DECIDED *upon the creation of a new vocal music which employs a unmatrixed production of vocal sound as the most immediate representation of thought. The primary concern is with the execution—equentially, chordally, or contrapuntally—of different processes of severe concentration, "mental" or "sentient" states, for which vocal sound is used as the fundamental physical coordinate.*

A prechoreographed navigation through specified mental & sentient states, underscored by a subtext of personal and rather cinemato- graphic writing, determines the sonic/linguistic content/gesture. In this way, I immediately establish a contextual basis for the composi- tional interconnection among sonic & linguistic elements, an inter- connection which, at the outset, is a part of the production of the individual materials themselves. During performance, I endeavor to move elastically through many different "states of severe concentra- tion" or "trance states" with complete obedience to the rigor of each state, and simultaneously attend to the temporal demands of the macrostructure of the piece... endeavors and concerns which reflect an obsession with the shared and unshared pleasures of both flagel- lant and flagellee.

WILD WOMEN WITH STEAKNIVES is a kind of blood- less and unmerciful brain surgery, a kinesthetic representation of the mind diffracted into an infin- ity of crystals... the subtractive synthesis of mental entropy into various bands of absolute and mere schizophrenia.

Theatrically, this diffraction of the mind is made infinite through a ceaseless navigation of the follow- ing variables: physical body effort & shape; changing light series which are choreographed; vocal timbre chains; incremental change of room reverberation;

manipulation of sonic spatial coordinates and tra-
jectories through the use of four to five microphones
distributed through a quadrophonic sound system.
With the exception of the changing light series, the
performer has control over all of the above during
the performance. An obvious advantage of the use of
multimikes is their service as a micromodel for the
plastic performance space itself, also choreographed
by the performer.

About virtuosity...
A vocal-timbre mapping onto this mental diffraction
requires a huge repertoire of vocal sound at one's
disposal as well as a completely elastic vocal ability,
which enables the rapid navigation through these tim-
bral elements. This is certainly not a new idea, but the
absolute accuracy, the absolute detail I am referring
to requires a virtuosity, a versatility with the
instrument that has not yet been approached. The
most minimal or the most maximal increment of tim-
bral change over the smallest unit of time is required
and, in many ways, resembles what is attempted in
subtractive synthesis of white noise, wherein highly
specified pitch/timbre bands may be heard suddenly
alone, in quick succession, or simultaneously.

The question here is not one of simplistic develop-
ment of vocal virtuosity. Rather, it involves a redefi-
nition of a most accurate sonic representation of
thought via the most accessible, direct, and sophisti-
cated music-making apparatus.

—*Diamanda Galás, San Diego, 1982*—

Wild Women with Steaknives

I commend myself to a death of no importance,
to the amputation of all seeking hands,
pulling, grasping, with the might of nations,
of sirens, in a never ending bloody bliss
to the death of mere savagery
and the birth of pearly, white terror.

Wild women with veins slashed and wombs spread,
singing songs of the death instinct
in voices yet unheard,
praising nothing but the promise of Death on earth,
laughing seas of grinning red, red eyes,
all washed ashore and devoured
by hard and unseeing spiders.

I commend myself to a death beyond all hope of
 redemption,
beyond the desire for forgetfulness,
beyond the desire to feel all things at every moment,
But to never forget,
to kill for the sake of killing,
and with a pure and most happy heart,
extoll and redeem Disease.

Words and music by Diamanda Galás (1982)

[*Photo: Paula Court*]

1 Multimike Declamations ≈ 3 minutes

space: [notation] → Monophonic and Triphonic [notation] → stereophonic use mikes 3,4

processing: Mike #1 → ADA 512 msec delay 50% regeneration
use all mikes

Mike #2

Mike #3 → Lexicon 42 pcm 200 msec delay

Mike #4

time : extremely rapid delivery of ♪♩♩♪♩ of tg and s, uneven/irregular rhythms punctuated by very regular rhythms

pecl

pecl

pecl

pecl

pecl

7 10 Finale ≈ 4' minutes

Prayer for Redemption
Vibrato/ululation ostinato → non verbal
 declamations
Vibrato pitch range moves by
microtonal increments c'''
 c''

Space :

 Vibratos : Monophonic
 Xa

 ◦Ṣ ẋ ẋ ṣ ᶑ = Quadrophonic

Reverb pedal = for section a),
 see pedal notes
 Section #3
 for section b),
 see pedal markings
 Section #1

a)

b)

Processing :

Mike # 1 < ADA 512 msec delay
Mike # 2

Mike# 3 < Lexicon 42 pcm
Mike# 4 200 msec delay

Panoptikon

I have become a stranger to my own needs
 and desires
I look and see things that are not there

And I ask myself
And I ask
And I ask
And I ask
And I ask
 I say:
What is my name?
What is my name?
What is my name?
What is my name?
What is my...

What is your name, darling
What is your name, angel
What is your name, honey
What is your name, baby
What is your name, baby
What is your name, baby

Your name is that of a condemned man
Your name is that of a condemned man
 You have no name

We both had knives
high school education

I WILL NOT BE SEDATED
I WILL NOT BE SEDATED
I WILL NOT BE SEDATED
I WILL NOT BE SEDATED

I stuck a knife into his heart and he pleaded
with me,
and it felt like making love to him.

A prisoner cannot be subdued
even with a knife at throat.
That is why at this time he is a
prisoner.
It is the essence of being a prisoner
today
he cannot be subdued, only
murdered.

I WILL NOT BE SEDATED
I WILL NOT BE SEDATED
I WILL NOT BE SEDATED
I WILL NOT BE SEDATED

He cannot be subdued,
only murdered
He cannot be subdued,
only murdered
He cannot be subdued,
only murdered
He cannot be subdued,
only murdered

You know, murderer's got to pay
 I say, KILL 'EM in vein
 KILL 'EM in vein.
 Kill him in vein.

I CALL YOU,
 Can we know the truth at last?
I CALL YOU,
 Do you send me dead flowers?
I CALL YOU,
 Do you know me now at last?
I CALL YOU,
 Do you know my father's name?
I CALL YOU,
 Before the first breath of angels?
I CALL YOU,
 Can't I make my peace at last?

Goddesses before mercy and old age,
Take this child up the ladders to the storm,
Shave from her soul his reptilian grace
And send her to a death beyond temptation.

How I wish this would all end.
How I wish I could walk free in this world
And could find my life again,
And see and do things that other people do.
I don't see how that would be possible right now, though
Too much has happened
For too long
To me.

But you know
YOU KNOW:
We, insects, have learned how to see in the dark.
We have committed to memory the palace of despair,
And what we see now are

ANGELS!
ANGELS!
ANGELS!
ANGELS!
ANGELS!

Dark night, make my bed.

Words and music by Diamanda Galás (1981)
with excerpts from Jack Abbott's Belly of the Beast

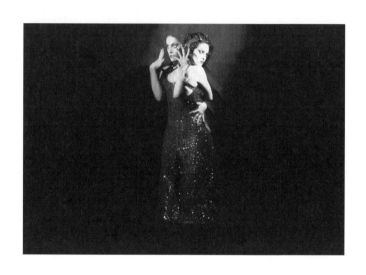

[*Photo: Kevin Boyle*]

Song from the Blood of Those Murdered

Τραγούδια από το Αίμα Αυτών που Έχουν Φονευθεί

Γιατί;
Γιατί;
Γιατί;
Γιατί;

Ελάτε
Ελάτε αδελφοί μου,
Ελάτε μαύρες ψυχές
Ελάτε γοργόνες

Δόσμου τα μαύρα μάτια,
Δόσμου το μαύρα μαλλιά
Δόσμου το μαύρο χέρι
Δόσμου την μαύρη καρδιά

Πηγαίνε στην χώρα του εχθρού
 με όλα τα στομάχια σας.
Ελάτε, θανατός.

Ερώτηταν:
Πού είναι η ψυχή σου;
—Δεν ξέρω. Είναι αποκάτω από τον γην
 με τις γοργόνες που φωνάζουν.

Ερώτηταν:
Πού είναι τα μάτια σου;
—Δεν ξέρω. Είναι στο το βουνό
 με τους γέρους που δελάνε.

Ερώτηταν:
Πού είναι η καρδιά σου;
—Δεν ξέρω. Είναι στην θά Αυττα
 με τις μαύρες αράχνες.

Γιατί;
Γιατί;
Γιατί;
Γιατί;

Αιφνίτε στην χώρα του εχθρού
με όλα τα στομάχια σας.
Ελάτε, Θανατός.

Τώρα βλέπω την αλύθεια.
— Ο Θάνατος θα σε πάρει
Και βλέπω θαμμένους δυο μηνών.
— Ο Θάνατος θα σε βρει
Και βλέπω τα φεγγάρια.
— Γιατί προσπαθείς να ξεφύγεις;
Και βλέπω τα χέρια του Θανάτου.
— Ο Θάνατος θα σε πάρει
Και βλέπω τον μάνα μου.
— Ο Θάνατος θα σε βρει.

Αμάν Αμάν
Αμάν Αμάν
Αμάν Αμάν
Αμάν Αμάν

Γιατί δεν γνωρίζεις ότι θα επιστρέψουμε
μία μέρα;
Προσέξτε: Γιατί δεν θα ξεχάσουμε!

[*Photo: Chrysantha Schultz*]

Malediction

The arms that you cut off that Sunday night
of the youngman who ran screaming through
 the street,
streaming blood in trails of terror,
are the arms that point me to my door,
which forsaken by the blood of Jesus,
invites the Devil, who now waits for me outside.

The arms that you cut off that Sunday night
are the arms that point me to the red eyes
of the pentacostal killers and the black eyes
of the roman catholic killers and the blue eyes
of the pinhead skinhead killers,
and the dirty angel does his target practice night
 and day,
making ready now to steal my soul away.

The arms that you cut off that Sunday night
are the arms that wait between my T.V. and my gun,
while the winks and smiles of singing debutantes
 and eunuchs whisper,

"We don't want you, Unclean, lying there in vomit,
 filth, and perspiration,
coming back with Elvis or with Jesus from the dead."

The arms that you cut off the body
of the screaming youngman
dance before my eyes the endless murder of my soul

which, taunted every hour by open windows,
has kept itself alive with prayer,
but not for miracles,
and not for heaven.
Just for silence
and for mercy
until the end.

Words and music by Diamanda Galás (1988)

LET'S NOT CHAT ABOUT DESPAIR

You who speak of crowd control,
of karma, or the punishment of God:

Do you fear the cages they are building
in Kentucky, Tennessee and Texas
while they're giving ten to forty years to find a cure?

Do you pray each evening out of horror or of fear
to the savage God whose bloody hand
commands you now to die, alone?

LET'S NOT CHAT ABOUT DESPAIR.
LET'S NOT CHAT ABOUT DESPAIR.

Do you taste the presence of the living dead
while the skeleton beneath your open window
waits with arms outstretched?

Do you spend each night in waiting
for the Devil's little angels' cries
to burn you in your sleep?

Do you wait for miracles in small hotels
with seconal and compazine
or for a ticket to the house of death in Amsterdam?

LET'S NOT CHAT ABOUT DESPAIR.
LET'S NOT CHAT ABOUT DESPAIR.

Do you wait in prison for the dreadful day
the office of the butcher comes to carry you away?

Do you wait for saviors or the paradise to come
in laundry rooms, in toilets, or in cadillacs?

Are you crucified beneath the life machines
with a shank inside your neck
and a head which blossoms like a basketball?

Let's not chat about Despair.
Let's not chat about Despair.

Do you tremble at the timid steps
of crying, smiling faces who, in mourning,
now have come to pay their last respects?

In Kentucky Harry buys a round of beer
to celebrate the death of Billy Smith, the queer,
whose mother still must hide her face in fear.

You who mix the words of torture, suicide and death
with scotch and soda at the bar,
we're all real decent people, aren't we,
but there's no time left for talk:

Let's not chat about Despair.
Let's not chat about Despair.
Let's not chat about Despair.
Please
Don't chat about Despair.

Words and music by Diamanda Galás (1988)

Double-Barrel Prayer

The dogs have come today
The dogs have come to stay
It's time to get your gun out
And drive the dogs away

They can smell your blood inside
It's too late to go and hide
The dogs are on their way
Prepare yourself today

Glory to God in the highest
and on earth peace to men of good will
We praise thee; we bless thee;
we adore thee; we glorify thee
We give thanks to thee for thy great glory
O Lord God, Heavenly King,
God the Father Almighty,
O Lord, the only begotten son, Jesus Christ,
O Lord, Lamb of God, son of the Father

The dogs know when you're sleeping
They know when you're awake
How fast your heart is beating
So be ready, or too late

They'll drag you by the collar
And they'll take you through the town
Your friends can help no longer
Once your ass is on the ground

[*Photo: Emily Anderson*]

Thou who takest away the sins of the world,
have mercy upon and receive our prayer
Thou who sittest at the right hand of the Father,
have mercy upon us
For thou art holy,
thou only art the Lord, thou only, Jesus Christ, art most high,
with the holy ghost in the glory of God the Father.

The dogs have come today
The dogs have come to stay
The dogs want you to pay
And this is what I say:

The trick to saying prayers
When the Devil's in the way
Is to help God pull the trigger
On the dogs this Judgment Day

AMEN.

Words and music by Diamanda Galás (1988)
with excerpts from the Gloria Mass

LET MY PEOPLE GO

The Devil has designed my death
and he's waiting to be sure
that plenty of his black sheep die
before he finds a cure.

O LORD JESUS, do you think I've served my time?
The eight legs of the Devil now are crawling up my
 spine.

The firm hand of the Devil now
is rocking me to sleep
I force my blind eyes open, Lord
but I'm sinking in the deep.

O LORD JESUS, do you think I've served my time?
The eight legs of the Devil now are crawling up my
 spine.

I go to sleep each evening now
dreaming of the grave
and see the friends I used to know
calling out my name.

O LORD JESUS, do you think I've served my time?
The eight legs of the Devil now are crawling up my
 spine.

O LORD JESUS, do you think I've served my time?
The eight legs of the Devil now are crawling up my
spine.

O LORD JESUS, here's the news from those below:
The eight legs of the Devil will not let my people go.

Words and music by Diamanda Galás (1988) and traditional

Birds of Death

Comes the night
comes the cold
comes the face
of the one I love

I see the birds
upon the rock
the crows that knew your name
and came on time

L I G H T S O U T
L I G H T S O U T
L I G H T S O U T
L I G H T S O U T

I see your eyes
we held your hands
What did you think about
until the angels came

Birds that love you know
what you know now
Could I have stopped them
from holding you down

L I G H T S O U T
L I G H T S O U T
L I G H T S O U T
L I G H T S O U T

[*Photo: Rotem*]

Friends and lovers
the night draws near
your eyes don't fool her
who knows your fear

Birds of death
I've seen you all before
Birds of love cry
"This is yours no more!"

L I G H T S O U T
L I G H T S O U T
L I G H T S O U T
L I G H T S O U T

What is the answer
to the waste of 10,000 days?
Your soul is now my destination
until the blackbirds come.

Words and music by Diamanda Galás (1988)

You Must Be Certain of the Devil

Welcome welcome welcome
welcome to the Holy Day
brother brother brother
sister sister sister
you must be certain of the Devil
on the Holy Day
You must be certain on the Holy Day

The flies are coming, mother
and the end of the day
The flies are coming, daddy
to steal my soul away
The flies are coming, sister
serve your brother while you may
WELCOME TO THE HOLY DAY
WELCOME TO THE HOLY DAY

You must be certain of the Devil
because he knows your name
You must be certain of the Devil
because he's counting on your shame
You must be certain of the Devil
because he's master of the game
You must be certain of the Devil right now.

It's time to take sides
don't wait up for nobody
It's time to realize
there's no victim but the willing

Party at Aldo Hernández' MEAT, after the New York premier of *Plague Mass*

It's time to recognize
no one waits for the dead man
No one but the Lord of the Flies

You must be certain of the Devil
because he knows your name
You must be certain of the Devil
because he's counting on your shame
You must be certain of the Devil
or you'll lose your aim
You must be certain of the Devil right now.

Deliver me from mine enemies, O my God:
defend me from them that rise up against me.
Deliver me from the workers of iniquity,
and save me from bloody men.

Be not merciful to the wicked transgressors:
They run and prepare themselves without
my fault: awake to help me and behold:
They belch out with their mouths: swords
are in their lips: for who, say they, doth hear?

But thou, O Lord, shall laugh at them.
The God of my mercy shall let me see
my desire upon mine enemies.

And at evening let them return, and let
them make a noise like a dog, and go round
about the city. Let them walk up and down
for meat, and grudge if they be not satisfied.

Because of his strength will I wait upon thee: for
God is my defense. Scatter them by thy power and break
their teeth, O God, in their mouth: BREAK OUT
THE GREAT TEETH OF THE YOUNG LIONS, O LORD,
AND WHEN HE BENDETH HIS BOW TO SHOOT
HIS ARROWS, LET THEM BE CUT AS IN PIECES!
*Bring them down, O Lord, our Shield.**

You must be certain of the Devil
because he knows your name
You must be certain of the Devil
because he's counting on your shame
You must be certain of the Devil
because he's certain of you
You must be certain of the Devil
right now.

The good man is present on the HOLY DAY
The good man is ready on the HOLY DAY
The good man is steady on the HOLY DAY
WELCOME TO THE HOLY DAY.

The key to the city
is to the man who doesn't run
The key to the city
is to the man who takes a gun
The key to the city
is to the man who keeps his friend
and to the man who doesn't leave him till the end.

The road to the city is paved in DESOLATION
The road to the city is paved in TRIBULATION

The road to the city is paved in DESPERATION
WELCOME TO THE HOLY DAY.

The road to the city is paved in RESIGNATION
The road to the city is paved in DESERTION
The road to the city is paved in DEVOTION

WELCOME TO THE HOLY DAY.
WELCOME TO THE HOLY DAY.

Words and music by Diamanda Galás (1988)
with excerpts () from Psalms 58, 59,* The Old Testament *(KJV)*

JUDGMENT DAY
To the saints of New York City, both the living, and the dead

Dead souls rising
Hear our crying
To the Jailers of the Dying:
You shall Hang on Judgment Day.

On that Day
The Dead shall wake thee
Wandering flesh shall all surround thee
To seal your fate on Judgment Day.

Let us call the guilty forward
Hang the sinner, Brand the coward
Let them burn on Judgment Day.

Run, you liars
Fate awaits thee
When your Faces shall expose thee
None can hide on Judgment Day.

Join the Paradise of Torture
While we pluck your tongues of murder
Hear our laughter Judgment Day.

Blood of sinners
Hear our shrieking
Blood of sinners all beseeching:
We shall drink you Judgment Day.

AMAN AMAN
AMAN AMAN
AMAN AMAN
AMAN AMAN

Join the Carnival of Feasting
While the worms your Flesh are waiting
Yes! We shall eat you Judgment Day.

Death defying
Let us gather
Praise the Warrior and Master
HAIL OUR SAINTS ON JUDGMENT DAY.

Words and music by Diamanda Galás (1992)

LISTEN, MAN

IT MAY SOON BE TIME

FOR YOU TO GUARD A DYING MAN

UNTIL THE ANGELS COME.

LET'S NOT CHAT ABOUT DESPAIR.

IF YOU ARE A MAN (AND NOT A COWARD)

YOU WILL GRASP THE HAND OF HIM DENIED BY MERCY

UNTIL HIS BREATH BECOMES YOUR OWN.

†

—*Diamanda Galás, 1988*—

"Do not churchgoers ask for the Second Coming, and do not
business concerns distribute to their shareholders profits from
merchandise of death, and do not superstates together with
'developing nations' live in anticipation, and is not the morbid
disconcern but a rejoicing in such anticipation?"

—Immanuel Velikovsky,
"The Age of Terror" *Mankind in Amnesia*

Excerps from

Plague Mass

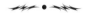

There Are No More Tickets to the Funeral*

This Is the Law of the Plague

I Wake Up and I See the Face of the Devil

Confessional*

How Shall Our Judgment Be Carried Out
Upon the Wicked?

Let Us Praise the Masters of Slow Death*

Consecration

Sono L'Antichristo*

Cris D'Aveugle

Let My People Go

.

*Included text by *Diamanda Galás (1990)*

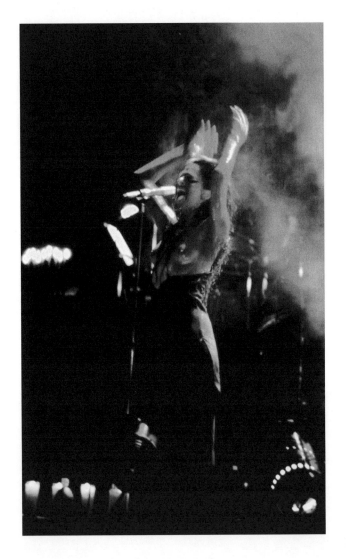

[*Photo: Robbie Lourenço*]

THERE ARE NO MORE TICKETS TO THE FUNERAL

Were you a WITNESS?
Were you a WITNESS?

And on that holy day
And on that bloody day

Were you a WITNESS?
Were you a WITNESS?

And on that holy day
And on that bloody day
And on his dying bed he told me
"Tell all my friends I was fighting, too,
But to all the cowards and voyeurs:
There are no more tickets to the funeral
There are no more tickets to the funeral."

Were you a WITNESS?
Were you a WITNESS?

And on that holy day
And on that bloody day
There are no more tickets to the funeral
There are no more tickets to the funeral
The funeral crowded.

Were you a WITNESS?
Were you a WITNESS?

"Were you there when they crucified my Lord
Were you there when they nailed him to the cross
Sometimes it causes me to tremble, tremble, tremble
Were you there when they crucified my Lord?"

Were you a WITNESS?
Were you a WITNESS?

"Were you there when they dragged him to the grave"
Were you there when they dragged him to the grave
"Sometimes it causes me to wonder, wonder, wonder"
Were you there when they dragged him to the grave?

And on that holy day
And on that bloody Day
Were you a WITNESS?

"Were you there when they laid him in the tomb
Were you there when they laid him in the tomb
Sometimes it causes me to tremble, tremble, tremble
Were you there when they crucified my Lord?"

Were you a WITNESS?
Were you a WITNESS?

SWING SWING
 A band of Angels coming after me
 coming for to carry me home

SWING SWING
 A band of Devils coming after me
 coming for to drag me to the grave

SWING SWING
 But I will not go
 And I shall not go
 I will wake up
 And I shall walk from this room into the sun
 Where the dirty angel doesn't run
 Where the dirty angel cannot go
 And brothers in this time of pestilence
 do know
 Each time that we meet we hear another sick
 man sigh
 Each time that we meet we hear another man
 has died

And I see angels angels angels devils
Angels angels devils
Angels angels devils
Coming for to drag me to the grave
 Angels!

Mr. Sandman makes a filthy bed for me
But I will not rest
And I shall not rest
As a man who has been blinded by the storm
and waits for angels by the road
while the devil waits for me at night
with knives and lies and smiles
and sings the "swing low sweet chariot"
of death knells
one by one
like a sentence of the damned
and one by one
of my brothers die

Unloved, unsung, unwanted
Die, and faster please,
we've got no money for extended visits
says the sandman

But we who have gone before
Do not rest in peace

Remember me?
Unburied
I am screaming in the bloody furnaces of Hell
and only ask for you
to raise your weary eyes into the sun
until the sun has set

For we who have gone before
Do not rest in peace
We who have died
Shall NEVER rest in peace
There is no rest until the fighting's done
And I see Angels Angels
Devils
Angels Angels
Devils
Angels Angels
Devils
Coming for to drag me to the grave

ANGELS!

Text by Diamanda Galás with excerpts from
"Were You There When They Crucified My Lord" *by Roy Acuff*

—44—

CONFESSIONAL

In that house
there is no time for Compassion,
there is only time for Confession
and on his dying bed they asked him

Do you confess?
Do you confess?

And on his dying bed the dirty angels
flying over him like buzzards asked him,

Do you confess?
Do you confess?

shshshshsh
It's so cold
It's so cold

shshshshs
It's so cold
It's so cold

Do you confess?
Do you confess?

Who *are* you?
Who *are* you?

Do you confess?
Do you confess?

Yes, I confess
Yes, I confess
When they laugh at the trial of the innocent
Yes, I confess

Let them laugh at the trial of the innocent
Swing swing
Let them laugh at the trial of the innocent
saying, "Here's the rope
and there's the ladder,"
Coming for to carry me home.
Yes, I confess

[TONGUES]

Yes, I confess
ANGELS! ANGELS!

[TONGUES]

Yes, I confess

Yes, I confess

 Yes, I confess:

GIVE ME SODOMY OR GIVE ME DEATH!

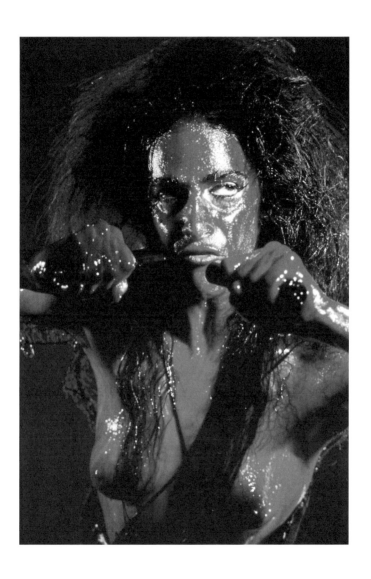

[*Photo: Tom Caravaglia*]

WHAT SYMPATHY IN *DEATH* DISCLOSES

WE WHO FESTER HERE

ARE VERY MUCH *ALIVE*

AND WATCH UNMANNED COMPASSION FLEE -

TO SAFER ZONES.

LET US PRAISE THE MASTERS OF SLOW DEATH

Sono L'Antichristo

Sono la prova I am the token
Sono la salva I am the salvation
Sono la carne macellata. I am the butcher's
 meat.

Sono la sanzione I am the sanction
Sono il sacrificio I am the sacrifice
Sono il Ragno Nero. I am the Black Spider.

Sono il scherno I am the scourge
Sono la Santa Sede I am the Holy Fool
Sono le feci dal Signore. I am the shit of God.

Sono lo segno I am the sign
Sono la pestilenza I am the plague
Sono il Antichristo. I am the Antichrist.

Dios, porque me has condenado?
maúpes apáxves!
lamma lamma sabácthani!
Esta es mi sangre.
Este es mi cuerpo.
Estas son mis venas.
Estoy siego.
Dios, no puedo ver!
maúpes apáxves!
lamma sabácthani!
 Aves de la muerte,
 Quiten me la vida!

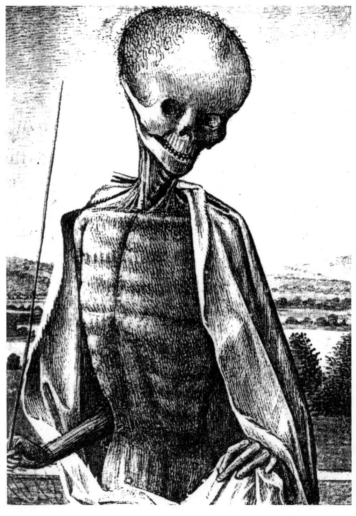

"Death with an arrow, rising from a tomb" Jean Colombe, France, late 1740s

"The sleep of a sick man has keen eyes.
It is a sleep unsleeping."

—Philocetes

VENA CAVA

I Wake Up and I See the Face of the Devil

Yes, I Like the T.V.

Breed

Do I See a Light

Old Dogbone

Why, It's the Angel of Death

Seance

.

Text by *Diamanda Galás (1992)*

I Wake Up and See the Face of the Devil

I wake up and see the face of the Devil
and I ask Him
What time is it?
What time is it?

What time is it?
What time is it?

What time is it?
What time is it?

What time is it?
What time is it?

How do you feel today?
What time is it?

How do you feel today?
Well, I think I'm feeling better
What time is it?
What time is it?

What time is it?
What time is it?

How do you feel today?
Well, I think I'm feeling better.

Do you?
Yes, I think I'm feeling better;

you know I was just thinking if I
could just get out of here some time and do
 something, you
know, and stop looking at the TV and just do
 anything at
all I would be so happy... just give myself
something to do, you know I...

Do you?
What time is it?
Better better better better
WHAT TIME IS IT?

How much time do you want?
I want? I want?
Why you... I want...

How much time do you want?
Well, I was just thinking that perhaps I
could have just...

Do you?
Better? Better? Better? Better?
How much time do I want?
I want... I want... How much time do I have?
Why you... why you... I want... I want...
no one knows... where I'm going...

You know we've been talking about you downstairs and
we think perhaps you are not being realistic—that perhaps
you are being unrealistic... it seems that you are not—we
think that you have not
faced up to what is going on...

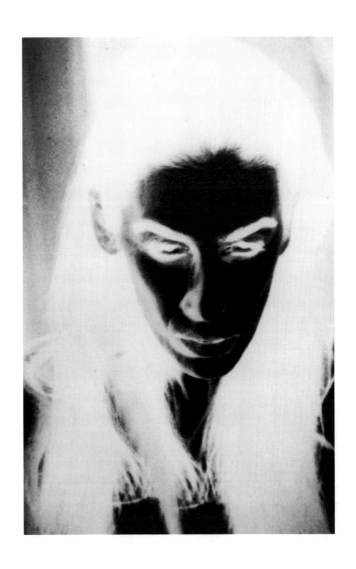

[*Photo: Robbie Lourenço*]

Better?
Better?
Better?
Better?

Are you sure, perhaps, you know,
you've gone insane...

Better?
Better?
Better?
Better?

Black!
Black!
Black!
Black!

White lights
White lights
White lights
White lights

Black!
Black!
Black!

White lights

Better
Better
Better
Better

.

sister, if I could do it all over again,
I would, but you know there's something
unnatural about this thing...
there's something UNNATURAL about this
thing... keep it in your memory...
people forget... about...

Hi, how are you?
Hi, how are you?

I'm fine
I'm fine

Hi, how are you?
how are you?

I'm fine
I'm just fine,
How are you, anyway?
and how are YOU
and how are YOU
any how are YOU

I'M JUST FINE, MISS THING
I JUST FEEL LIKE SINGING THE
BATTLE HYMN OF THE REPUBLIC!
HOW ARE YOU, *ANYWAY*?

GET OUT OF HERE
GET OUT OF HERE
GET OUT

GET OUT
GET OUT

Please don't go
Please don't go
Please don't go
You are the love of my life
I have never loved anyone like this before
and I never will again
Please don't go...

I'm sorry, miss
you can't come in now
he has developed shingles
and you could contract it
and it might be meningitis and
not be able to have children...

Children children children
Children children children
Children children children
Children children children

Am I having children?
When my baby is dying
When my baby is dying

THIS IS MY BLOOD
THIS IS MY BLOOD
THIS IS MY BLOOD

WHITE LIGHTS

WHITE LIGHTS
WHITE LIGHTS
WHITE LIGHTS

BLACK
BLACK
BLACK
BLACK

I dreamed I stuck a gun to my head and I dreamed
I was lying in a pool of blood
and they looked down at me
and said,

"It's over now...
it's over now...
Now, at least, he is in peace..."

"FREE"
"FREE"
"FREE"
"FREE"
turn the fuckin' light off!

.

I dreamed I was lying in the green grass
and the wind was blowing softly
and blue was everywhere
and I saw heads popping
out through the grass
and it seemed as if they knew me...
"Hi Dimitri, Hi Dimitri, Hi Dimitri, Hi Dimitri..."

"Heaven… Heaven… Heaven… I see Heaven…"

BLACK
BLACK
BLACK
BLACK

Yes, I Like the T.V.

Yes, I like the T.V.
goodness Mary grateful
friend all day night
white white white so
sparkle dim dim dim
not tight goddamn it

 not again

FUCK shit
piss
PISS
piss she's on quiet quiet
say it say it winfy
fatso hee hee love ya
me you me you me you me you me
you me you me you me you me
Don't
Don't
Don't
Don't say it Don't do it Don't do it Don't do it
Don't do it we you Shirley mother daddy my fault
deadbolt daddy dead help us open up open up
that's a winner that's a winner that's a winner

Listen,
When this is all over
I want you to remember
that I loved you
your beautiful eyes
your sweet patient smile
I know I've abused you
and acted like an old dogbone...

I want you to know
how beautiful you were to me
your goodness, your sadness
your sweet tears, your sacrifice
If I only had you in my life
it would have been well worth it

A dozen lies

"An evil voice will scream
horribly if it senses
that you are beginning
to listen to a sane voice"

Are you a troublemaker
[SCREAM]
was that a lying scream
correct me correct me
you troublemaker
[SLAP!]
A dozen lies for a tragic slave

Troublemaker is an evil voice
silence, fiend
 where are you going
 don't you telll me that!

[SCREAM]

 Correct me, but was that a lying scream?
 Perhaps.
 The evil voice is a liar. Don't forget that.

Service

But he's *alive*
Be quiet— he can *hear* yoo I can *hear* you
 he can *hear* yoo I can *hear* you
 he can *hear* yoo I can *hear* you
 he can *hear* yoo I can *hear* you

He's alive
He's alive
He's alive
He's alive

He's *not* sleeping!
He's *not* sleeping!
He's *not sleeping!*
He's *not sleeping!*

I don't know how long I can go on like this
Where is everyone
Scarecrow, scarecrow
Where is everyone

 Goddess?

It's twelve o'clock
687 678 678
White lights
WHITE LIGHTS
678 678 678
Alright let's go
678 678 678
Scarecrow scarecrow

Hi *girl*!
678 678 678

Once enchanted,
the beautiful Sandro
now was reduced
to a mountain of skin and bones
He could still appreciate beauty,
but it scorned him now.

Is that your daddy?
Is that your daddy?

 Hi daddy
 Hi girl

678 678 678 678
 Hi Girl!

scarecrow
scarecrow goddess, fuck me!
 HEE HEE HEE HEE HEE HEE HEE

Nursee Nursee Nursee
 unhand me, slattern!

 DO YOU SMELL SOMETHING
 BURNING?

 do you smell something burning?
 desdemona, can I phone ya?
 do you smell something burning?

 no, I would not like *those*
 don't *come* at me with that thing, missy

[SCREAM]

 well, wasn't *that* fun.

Oh my darling
are you lost again?
beyond the clouds
the angels hold you
sweetly singing
 darling
darling wait darling
 white lights white lights

 soft
 nice

WHITE

WHITE

I can see it
I have been there
before I
knew you
or anyone

I remember now
it was so long ago
I can see it
I can see it

What puncture?

 Puncture
 Puncture
 Puncture
 Puncture

Vena vena on the wall
who's the biggest fool of all
Vena vena on the wall
who's the greatest sucker of them *all*

Mother?

May I?

In point of fact I am *not* that fond
of butter—I know that I neglected
to mention it before, but,
in these final moments I feel I am obliged
to tell you the truth.

I can no longer live with the anxiety that secret has
caused me.

 SÉCRETS
 SÉCRETS
 SÉCRETS

 What's *your* secret,

 little boy
 little wonder boy

 HEE HEE HEE HEE

Take me down Mother...

Take me down Mother
Take me down
Down to the cellar in a garbage bag

Old dead boy
Friend of bugs
Soulmate to the worms
Burn
Burn
old body
skin and bones

Where's the old deathbird?

Birdie, catch me

Birdie, catch me

TAKE THIS SOUL

Breed

BREED

and from his throne

he could see the unceasing
breeding
of those
denied by genius

 Hey girlfriend it's time for GASH!

Mother, throw them fishes!

Fishee fishee on the wall
who's the biggest FUCK of all

Fishee
fishee
fish, fish
fishee
fish, fish
fishee

Hee hee glad to see ya

fishee fishee
fish fish fish

Gentlemen and ladies

now for the moment that we have all been waiting for

that final moment we have all beeen waiting for…

I shall rise from the ruins

of this little throne before you, and disappear

into the SUN

like a PHOENIX

Humorless cows!!!!

Could you be useful please?
That's it, stupid!

Bingo

She's got her finger on the bingo
you don't
you never will
 He said so
 so
 Fuck you
 fuck you and
 STOP IT
 STOP IT
 STOP IT
That's it—you've won a million dollars
Thank you so much Hello
This is Bobby

sending my love
I'm getting tired of speaking to your
answering machine, so unless you call me
I'll be seeing you, you selfish fucker
see you around

You have no right to your opinion.
Good morning.

I'm going to kill that cracker
I'm going to kill that cracker
I'm going to kill that MOTHERFUCKING bitch

Kill that cracker

Beat her to death and shut up, Mister!

"How could you *do* this to me. How could you
be so irresponsible. Couldn't you have controlled
yourself all those nights. Don't you know that you
have destroyed me. You have ruined my life. How
could you."

Alright that's it!
Ladies and gentlemen
Bingo!
678 678 678 678
Stop it stop it stop it stop it
Ladies and gentlemen
our prizewinner—
678 678 678 678 678 678 678 678 678

[Reprise]

Stay awake, little pony
Stay awake
Beat that sandman
Beat him again
Nonsense
Don't let that maniac
 come in here
This is a sacred place
Stay wake little pony
Stay awake
Don't let that man come in here
This is a sacred place

[x3]

Do I See a Light?

Do I see a light?
new
old man
good boy
new seed
old bone
go away
leaves gray
don't come back
another day
for clean
young boy
eyes new
me over
standing over
flush it
down there
no remorse
and
no forgiveness
little baby
say goodbye
don't forget
and
don't remember
I'm a
good boy,
mother
see me?
perfect.

Can you hear me
Do you know who it is
Honey
It's me
I'm right here
And I'll be here everyday, okay
So don't worry about anything
darling I'm right here
That's right
Concentrate on your breathing sweatheart
Everything's okay now
just dream darling just dream
Everything's alright honey
you can go to your dreams now
Dream darling
You can let go now
Baby
We're all safe together
And you can go now

How do you feel today
I feel fine / do you mean it /
can't / I know that / I want to / help /
234 6690 234 6690
lost it / where / where / doorway
dead shot
blue sky
yellow bird
nice girl
open close
how do you do
I think I'm good
 FUCKER
 FUCKER
Don't think
Don't think
Don't think

Out Out
get out of here
get out of here

678 678 678 678

Bingo!
You've won a million dollars!

[LAUGHTER]

Butcher butcher
on the wall
Who's the biggest fool of all

I am!
 me too
 and
 me too and you and me and also…
 How about you?

SHUT UP SHUT UP
SHUT UP SHUT UP

 678 678

Alright, move it out. Get out. OUT! OUT!

And although dismembered,
his twisted and disconnected limbs
rose in a cloud of glory
and they reigned over the timid and the fearful
as a symbol of courage and of truth unbounded
and a triumph over Death.

glory glory glory

[LAUGHTER]

glory glory glory

Today I awoke
up down
and I you
wasn't too much
tired awake
asleep baby pink
soft.
It was such a nice
girl day I was
astonished that it
was so
cheerful suprise
good boy now.
Were you ready for
bed—that? what
comes. Not at all
ten feet tall sir
ma'am.
Thank you.

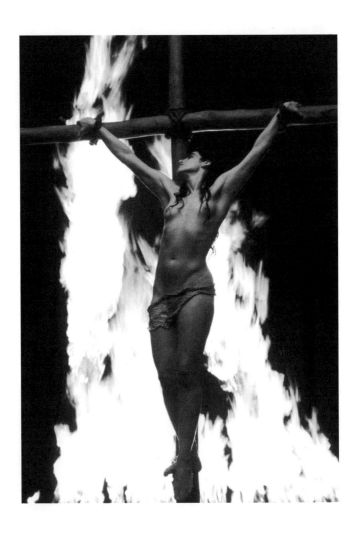

[*Photo: Annie Liebovitz*]

My God time—is it late?
passes—was that me again—
so slowly I just think—
IS it? Really? —time
to go—stop go stop go
stop stop stop
stop it
stop them
stop it
stop it
stop it
well...
if you can't eat it,
wear it we say
it's not so bad
shit
shit
shit
shit
shit
............catch!
 caught it
......................
 STINKER

boy oh boy…
 That was a good one
 smooth slick
 fluid viscous
 come and get it
 oops
 stop it
 stop it
 (VOMIT)
 get 'er
 get 'er
 oh boy
 oh boy boy
 boy girl boy girl
boy girl boy girl boy

OLD DOGBONE

Ladies and gentlemen
I would like to announce that
our special guest cannot be with us tonight
but instead Old Dogbone has consented to make an
appearance
gentlemen and ladies,
please give a warm welcome to
Old Dogbone.

Thank you, ladies and gentlemen. Hi Dimitri!

It is truly marvelous that you have consented to see
me tonight

...yes, but please don't call me that
I believe we discussed that years ago.
No it's a lovely name... I know that you
have given it a lot of thought, but I do
prefer the name of Sandro, thank you.

DOGBONE

DOGBONE

an old dog finds his home
an old dog has no more place to roam
an old dog dies in bed
and sleeps in paradise
forever, after.

WHY IT'S THE ANGEL OF DEATH!

Why it's the
Angel of Death!
got them needles?
back off mister glasses
don't touch
tell the truth
tell the truth
tell the truth
tell him Dona
you're not going nowhere, missy
I'm all wrapped up
like an Xmas gift
go go go!
go go go!
It won't hurt now?
SURE I feel it!
It won't hurt now
SURE I feel it!
go go go go
go go go!
Can't we stop it now
See that bulb?
SURE I see it!
Look it! Look it!
Look it again!
okay take it to the lab
good good goody
Oh them golden showers

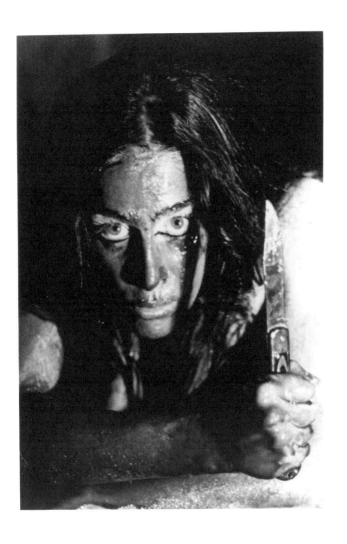

[*Photo: Dona Mc Adams*]

Fishee, see it?
Oh boy
Oh boy Fishee
Oh boy Fishee
Oh boy Fish

Fish

Fishee

Fish

Fish

Fishee
 get yer hands
off, Flo!
 yes
ma'am
 yes
ma'am
 yes
ma'am
 I know
 water please?

Oh them golden showers
takes me to Rome
where I never was before
 See it?
It's the statue of Dave…
how is it out there
in L.A., anyway?

I hear them
but I don't listen
never listen to them
all jump down on me
them me them me
surround and hole zero
puncture shot me steady steady steady
this minute

Alright—it's twelve o'clock. Let's Go:

zero bottom whole hole
circle happy children stop it
you're dead and I'm dead
Stop it fuckee stop

Again!
dot hole
hole puncture
angel dirty
liar murder
dead man
Stop it fuckee stop!

Go Again:
puncture zero
big hole
down stairs
dirty muddy
rain hole
Screaming Head and You're Dead
Stop it stop it fuckee stop stop!

eye head
white puncture
red doll
squeeze mother
dirty nasty
Evil baby
sleep torture
sunny Killer
pig Mother
slap me sinner
pig selfish
ugly bastard
nothing zero
hole tunnel
pink sky
OVER!
feel it fuckee
Lovely lovely free soft
Pink Pink Pink
I'm your baby

honey kiss me

birdie love me

up up
wsssh!

Seance

I miss you—it's been so long—how are you—
I'm fine—been out her so long—I remember us
together—so green there—so black there—
I just wonder how long I can go on—I think of you
always—I think of mother and patepa and gordon—
is he ok—I live in dreams now and try to
remember every detail of the past—I try to make
a perfect memory of everything that has gone
before—
now so far away from life—how many in the
hole now, falling off the earth like old men with
no history—do you remember—was I ever there
or am I dreaming—you must remember for me
because I'm losing days—help me o'er that
bridge it iis too far—I can not make it—one step
two steps—three steps—am I breathing—is this
a god I see crawling to my grave on hands and
knees and falling falling falling out of llight and
into darkness—hold me hold me ghosts of love
and lovely eyes can hold me in the sun when life
is done my angel are you there can you hear me
I am far away but not too far for dreams—your face
your face—grab me by the hand I will show you
where I am—darkness darkness—feel the wind
my angel are you there—hear my breathing—
I am near you waiting waiting see me smiling
smiling sun is everywhere… Now they take me
down the stairs… slowly, slowly—hold me,
hold me near…is that my judge? He sees me…

"For I know that my redeemer lives
A guarantor upon the dust will stand;
Even after my skin is flayed,
Without my flesh I shall see God."

—Job 19:25-26
(Dahood/Marvin Pope translation)

SHRIEK: as in rape, torture and other human experiments,
the SHRIEK of an animal which is repeatedly attacked
within a contained space.

SHRIEK: sound beneath the skin, traveling beneath the skin at
the pace of blood:intravenal song. Brain stem level.

Excerpts from

SCHREI X

1. Do Room
2. "I"*
3. M dis 1
4. O.P.M.
5. Headbox
6. Spider*
7. Cunt*
8. Hepar
9. Vein*
10. M dis 2
11. Smell*
12. Hee Shock Die*

..............

*Included text by *Diamanda Galás* (1995)

"I"

IIII
IIII
IIII
IIII
IIII IIII
IIII
IIII IIII
IIII
IIII
I I
I I
I I
I I
II I
II I
II

I I I I I I AM NOT I I I I AM
NOT I I I I AM NOT I I
I I AM NOT I I AN NOT II
AM NOT AND READY FOR
I I AM NOT AND READY
FOR AND I I I WHAT CAN
I I AM NOT WHAT
CAN I I DO NOT I I I AM
NOT AND I AM NOT THAT
WHAT WHAT WHAT I CAN
NOT WHAT I AM NOT I I I
THEY CALL ME I I I WHAT
CALL ME I I I WHAT

LAST NIGHT YOU CAME BACK, and you said you were
feeling so much better. Your feet were torn in two,
and your bowels were hanging from your mouth.
Your face was rotting, and I was afraid of you, come
back from the dead to ask if you could rejoin us now,
and you didn't die after all, it just kept rotting you
away, and it had only appeared to us that you had
died and destruction stopped—no instead you had
been taken, you had been taken somewhere else and
no one knew not even you, but you stood in the
room saying, "But, Look! I'm so much better," and
you frightened me because I knew then that you
could never come back to the land of the living, but
that you were condemned to live in the land of the
dead forever, in the colony of lepers that would have
you, you so frightening to behold... Then our father
came into the room with a large black dog, said, "I've
got to take the dog for a walk now," to send you back
to the grave where you really live now, he was
suprised that you had the temerity to try and rejoin
the healthy, and then I saw you leave us through the
garden, your head bent down, crying softly, and then
I awoke to a horror much greater than ever before
because there is no peace where you are dead, not for
you and not for me, never, never anything but sad-
ness, and we will never never never never never never
be happy, ever again.

Spider

SPIDER OF FLESH DON'T KNOW ME
GOT THEM AROUND ME

ONE LEG, KNOCKING ON MY DOOR
CRAWL ME IN MY DREAMS

TWO LEG, TAPPING ON THE GLASS
RUNNING DOWN THE STAIRS

THREE LEG, SCREAMING ON THE WALL
LAUGHING ON THE CHAIR

FOUR LEG, WHO'S THAT SLEEPING IN MY BED
I KNOW YOU, I ALWAYS HAVE, AND I ALWAYS
WILL,
OH MY GOD

FIVE LEG, SIX, THEY'RE ALL AROUND ME
AND I WAS ONLY ASKING TO BURN
BEFORE THEY BURIED ME ALONE WITH YOU

SIX LEG,SEVEN, THE SPIDER HAS HIS TEETH
AROUND MY NECK,
MY GODDESS , HELP ME
I AM SO SORRY FOR MY CRIMES I DON'T
REMEMBER
WHAT I

SEVEN LEG, EIGHT!!! SORRY STUPID
SORRY STUPID
SORRY STUPID
SORRY STUPID SORRY STUPID SORRY
STUPID SORRY STUPID OH MY GOD
I CAN'T REMEMBER WHY I —

CUNT

CUNT
CUNT CUNT CAN'T HOLD IT
CUNT CUNT WHO'S THAT SLEEPING NOW

CUNT CUNT
BUT I CAN'T
CUNT CUNT

YOU DON'T FIND MYSELF SLEEPING
CUNT CUNT
SLEEPING HERE YOU DON'T FIND MYSELF

CUNT CUNT WHO'S SLEEPING NOW
SHUT UP AND CUT THAT VEIN
SHUT UP AND CUT THAT VEIN

CUNT CUNT —————
CUNT CUNT —————
CUNT CUNT —————
CUNT CUNT —————
CUNT CUNT —————
CUNT CUNT —————
CUNT CUNT —————
CUNT CUNT —————
CUNT CUNT —————
CUNT CUNT —————

VEIN

SHE'S NOT IRONING
FOR YOU
LOVE YOU
FOR YOU
CAN'T LOVE YOU
SHE'S LYIN
FOR YOU CUNT
FUCKING BITCH
SHUT UP AND CUT THAT VEIN
I KNOW YOU'RE
AND I KNOW YOU'RE
YOU DON'T SEE YOU
TAKE THAT
CUNT—COME ON
TLOH DI DLOH

FLESYM TEW TNOD ESAELP MON QNIEELS
SEH'S TO DLOH TNAC TI EREH FO TUO TEG
O TOG I REH EVAEL TAC I TUB HCUOT
TNOD

HCOUT TNOD REH EVAEL TNAC I TUB
EREH FO TUO TEG FO TOG I -TI
DHLOH TNAC I WON GNIPEELS SEHS
FLESYM TNOD ESAELP

ESALP TNOD TEW FLESM SEHS
GNIPEELS
WON I TANC DLOH TI I TOG OT
TEG TUO FO EREH TUB I TANC EVAEL
REH TNOD HCOUT!

SMELL

BLACK? I see nothing—are they gone
now? I can't hear her—walking on
the stairs—are you ready for bed? I
can't hold it—where are those footsteps
who's that sleeping in my-darkness oh
my god I can not smell a thing—is she
standing over my bed? god help me,
who's that knocking, and I'm all gone
now, and over that fence—no one can
see me, please run away and it's all up
so are you ready?

BLACK? I cannot see them sleeping
in my bed—spider of flesh don't
know me, turn that pig over, I can't
see them—have I a minute before
the sun goes down who's that standing,
standing standing over?

Oh God, do you smell that? It's the
smell of Death.

HEE SHOCK DIE

OK GO
OK GO
OK GO
OK GO
OK OK
OK
OK
OK
OK
OK
OK
O
O
O

SAY
SAY
SAY
OK
OK
OK
OK

AAA
AAA
AAA

WOOH
WOOH
WOOH
WHEE
WHEE
WHEE
WHEE
WHEE
WHEE
WHEE
WHEE AH IH OO IH OO AH
WHEE AH IH OO IH OO AH
WHEE AH IH OO IH OO AH
WHEE AH IH OO IH OO AH
OK
OK

KICK MY HEAD

KICK MY HEAD

KICK MY HEAD

SHA AH AH AH AH AH AH
SHA AH AH AH AH AH AH

OKAY
OKAY
OKAY
OKAY

SHA SHA SHA
RA
RA
RA

RA
RA
RA

RA
RA
RA

RA
RA
RA

RA
RA
RA

RA
RA
RA

AH
AH
AH

AH
AH
AH

AH
AH
AH
AH

AH
AH
AH
AH
AH

AH
AH

AH
AH

"What profit is there in my blood,
and of whom shall I be afraid…"

—Diamanda Galás, "I Shall Not Fear"

INSEKTA: the survivor of repeated trauma, trapped in an
enclosed space without opportunity for escape.

INSEKTA: nameless, contemptible, dishonored—in reference
to populations whose anonymity and perceived powerlessness
make them convenient for research.

Excerpts from

INSEKTA

Sanctus

Apocalypsis

What Is My Name*

Nekropolis

I Shall Not Fear*

Nomen Exterminus*

It's Getting Dark Outside

.

*Included text by *Diamanda Galás* (1993)

"I am the signature anonymous, an experiment in nature."
—*Diamanda Galás*

What Is My Name

I.

WHAT IS MY *NAME*
AND *WHAT* IS MY NAME ALL FALL DOWN
AND *WHAT* IS MY NAME GO *AWAY* ONE *TWO*
AND *WHAT* IS MY NAME GO AWAY ONE *TWO*
AND TWELVE O'CLOCK
AND *WHAT* IS *WHAT* IS MY ALL FALL DOWN
GO AWAY ONE *TWO*
AND GO *AWAY* HIS *NAME* IS ALL FALL DOWN
ONE TWO
AND HE IS GO *AWAY* TWELVE O'CLOCK ONE
TWO WHAT IS MY
NAME *HE* IS I CAN'T ALL *FALL* GO *AWAY* HE IS
AND
ALL FALL DOWN GO *AWAY* AND JACK IS ON
THE *HILL* ALL GO *AWAY*
ONE *TWO* DON'T *YOU* GO ONE *TWO* HE
ISN'T AND FALL DOWN
AND WHAT IS MY *NAME*

2.

AND WHAT IS MY *NAME*
DO I KNOW *YOU* HE IS *NOT* ALL FALL DOWN
YOU'VE *GOT* ME *THANK* YOU
AND SHE RAN *THERE* WHAT *IS* MY *TELL* HIM
GO *AWAY* I KNOW *YOU*
WHAT *IS* AND *ISN'T* IT HE WILL *NOT* GO
AWAY I *CANNOT* TWELVE O'CLOCK
COME *BACK* CAN'T *SAY* IT TELL THE TRUTH

ONE TWO *JILL* IS NOT
WHAT IS OPEN *WIDE* DON'T *TELL* THE ONE
TWO *GO* TO *BED* CAN'T TELL *YOU*
I KNOW YOU CAN'T GO AWAY ONE TWO AND
GO AWAY *I KNOW YOU* AND FALL DOWN
AND WHAT IS MY *NAME*

3.
AND WHAT IS MY NAME
I KNOW *YOU* CREAM OF CORN ONE TWO
TWELVE *O'CLOCK*
ONE TWO CREAM OF CORN I KNOW *YOU*
HELP *ME* TELL THE TRUTH
I KNOW *YOU* TWELVE O'CLOCK TIME
LIGHTS *OUT* TELL THE *TRUTH*
ONE TWO GO TO BED
AND I KNOW *YOU* TWELVE O'CLOCK AND
PLEASE HELP GO *AWAY* AND HE IS
ON THE *HILL* GO AWAY ONE TWO ALL FALL
DOWN DON'T LEAVE ME AND
TWELVE O'CLOCK HELP *ME* AND PRETTY
DON'T GO AWAY ONE TWO
I LOVE *YOU* CAN'T TELL THE *TRUTH* GO AWAY
I KNOW YOU CREAM OF CORN
AND WHAT IS MY NAME

4.
AND WHAT IS MY HELP GO AWAY ONE TWO
OPEN LIGHTS OUT TELL THE
HELP ME DON'T PRETTY DON'T GO AWAY
HE KNOWS *ME*

ONE TWO WHAT IS MY ISN'T IT DON'T MOVE
HERE GO AWAY MOTHER HELP US
GO AWAY PRETTY WHERE ARE *YOU* DON'T GO
AWAY LIGHTS OUT DON'T SEE *ME* HERE
GO AWAY LIGHTS OUT ONE TWO DON'T SEE
ME LOST GONE AWAY
I *KNOW YOU* DON'T BREATHE AND ONE TWO
HE KNOWS ME
PRETTY STAY IT'S LATE ONE TWO GO AWAY I
KNOW YOU HELP ME
CAN'T MOVE AND LOOK IT LOOK IT LOOK
IT GO AWAY I SEE YOU
LOOK IT *LOOK* IT LOOK IT THERE'S *NO ONE*
LOOK IT LOOK IT LOOK LOOK IT
CAN'T TELL YOU *LOOK* IT *LOOK* IT *LOOK* IT
WHO'S THAT SLEEPING IN MY
LOOK IT LOOK IT LOOK IT WHAT IS CREAM
OF CORN GO *AWAY* HELP
PLEASE THANK YOU
DON'T SEE *ME* GONE *AWAY* LOST A DAY TOO
BAD SO WHAT MOTHER HELP *ME*
WHAT IS MY NAME AND *LOOK* IT *LOOK* IT
LOOK IT DON'T LOOK *THERE* AND GO AWAY
I KNOW *YOU* IT'S ON THE WALL THERE ARE
TWO PRETTY PRETTY PRETTY ON THE WAY
ONE TWO PRETTY PRETTY PRETTY DO YOU
SEE IT PRETTY PRETTY PRETTY I THINK I
PRETTY PRETTY PRETTY PRETTY PRETTY
HELP ME OR TWO PRETTY PRETTY
CAN'T YOU STOP IT HELP GONE AWAY LOST A
DAY TOO BAD SO WHAT
HEAVEN HELP US *WHAT* IS MY PLEASE GO
AWAY

HELP HELP HELP HELP HELP HELP
HELP HELP HELP HELP HELP HELP
HELP HELP HELP HELP HELP HELP
HELP HELP HELP HELP HELP HELP

CRITICAL CRITICAL CRITICAL CRITICAL
CRITICAL CRITICAL CRITICAL
CRITICAL CRITICAL CRITICAL CRITICAL
CRITICAL

ONE TWO LET THEM *SEE* IT DON'T THEM *SEE*
IT I ME *TWO*
YEAH YEAH YEAH!
YEAH YEAH YEAH
YEAH YEAH YEAH AND YEAH YEAH YEAH!
AND YEAH! YEAH! YEAH! AND
YEAH YEAH YEAH AND WHAT IS MY AND
YEAH! YEAH! YEAH!

5.
I TRIED TO DO IT BUT I JUST COULDN'T
LEARN IT YOU KNOW HOW SOME
DAYS IT'S REALLY COLD OUTSIDE AND YOU
JUST CAN'T SEEM TO SHAKE
IT CAN'T MOVE OR OPEN UP ITS JUST SO
DARK OUTSIDE YOU THINK
YOU'LL NEVER MAKE IT OVER THERE I JUST
DON'T SEE HOW PEOPLE
CAN WAKE UP AND DO IT EVERY DAY THEY
GO OUTSIDE THEY BOUGHT
THEIR BREAD AND WENT OUT TO DO THE
THINGS NORMAL PEOPLE DO

ME GO TO BED I'M NOT REALLY
THERE TODAY AND GONE
TOMORROW LIKE THE SPARROW KILL
THOSE PIGEONS I SAID KILL
THOSE PIGEONS THEY TOLD ME WHEN THE
CLOCK WAS UP I TOLD
THEM BEFORE *I'LL KILL YOU FIRST* "TIME'S UP"
THEY TELL ME THIS
MORNING HATE THE LIGHT OUTSIDE YOU
DON'T KNOW NOTHING
CAW-CAW-CAW FILTHY FUCKS GO GET MY
GUN OUT *MINUTE* HAND
DON'T TELL ME *NOTHING* I'M GOING HOME
ALONE YOU CAN'T COME
FILTHY FUCKER SHITBIRDS KILL THEM GIVE
ME LIGHT I CAN'T GO THERE
ITS *TOO* LIGHT FLAP FLAP THAT'S NOT MY
HOUSE PLEASE LET ME GO I
WILL NOT TELL THEM GO AWAY I CANNOT
TELL THE TRUTH TELL THE
TRUTH KICK IT KICK IT CUT IT I'LL CUT
YOU SHUT UP BITCH I
MEAN IT YOU'RE NOT SO GOOD ANYWAY
SHUT UP SHUT UP SHUT UP
TAKE IT *TAKE* IT *TAKE* IT YOUR FUCKING
MOUTH YOUR FUCKING STUPID
STUPID DUMBO FUCK YOU DUMBO FUCK
ME FUCK ME DUMBO LOOK IT
LOOK IT LOOK IT LOOK IT LOOK IT LOOK
IT LOOK IT GOT IT WATCH ME
WATCH ME WATCH ME KILL
THAT BIRD I MEAN IT!

I Shall Not Fear
Torture section

Though a host should encamp
against me
I shall not fear.

Though they come to bear false witness
against me
I shall not fear.

Though a host comes to part my flesh
I shall not fear.

> What profit is there in my blood and
> of whom shall I be afraid?

They that take counsel together against me
I shall not fear.
Though they come to take away my life
I shall not fear.
Though they make me as one forgotten

> I shall not fear.

What profit is there in my blood and
of whom must I be afraid?

His voice is on the water
They maketh me to skip like a calf
His voice divides the flames of fire

He shall prevent the dawning of the morning.
Mine eyes will mediate in the night watches.
This is the day the Lord hath made
and I cried:
I hope in thy word.
Save me I beseech thee.

What profit is there in my blood and
of whom shall I be afraid?

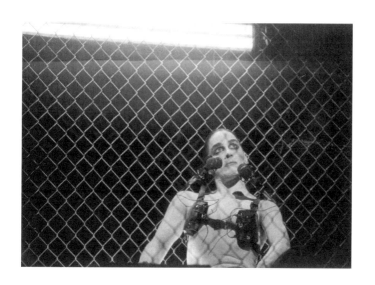

[Photo: Beatriz Schiller]

NOMEN EXTERMINUS

Io, Nomen Exterminus
I am the dead one
I've gone too far now
I can't go back
I cannot feel this
cannot afford to
there is too much here
I'm not alone
where is the end?
there's no escaping
there is no ending:
I dig my grave.

NOMEN EXTERMINUS
NOMEN EXTERMINUS
NOMEN EXTERMINUS
NOMEN EXTERMINUS

I see them crawling
Please stop that screaming
I tell them not to
I need my ending
O please I beg you
I tell them not to
I cannot hold it
My bowels break it
I cannot stop it
I have come only
I have come only
to kill my god.

NOMEN EXTERMINUS
NOMEN EXTERMINUS
NOMEN EXTERMINUS
NOMEN EXTERMINUS
NOMEN EXTERMINUS
NOMEN EXTERMINUS
NOMEN EXTERMINUS
NOMEN EXTERMINUS

I now kill him
from whence all came
and all return
but for this moment
I do forsake him
who holds my morning
and my evening
I do forsake thee
I walk without thee
and in the shadow
of the dead man
whose blackness conquers
whose sadness lingers
whose laughter renders
and casts asunder
your bathetic tears
and so I kill you
o master trickster
and now am free

NOMEN EXTERMINUS
NOMEN EXTERMINUS
NOMEN EXTERMINUS
NOMEN EXTERMINUS
NOMEN EXTERMINUS
NOMEN EXTERMINUS
NOMEN EXTERMINUS
NOMEN EXTERMINUS
NOMEN EXTERMINUS
NOMEN EXTERMINUS
NOMEN EXTERMINUS
NOMEN EXTERMINUS
NOMEN EXTERMINUS
NOMEN EXTERMINUS
NOMEN EXTERMINUS
NOMEN EXTERMINUS
NOMEN EXTERMINUS
NOMEN EXTERMINUS

host shall sacrifice me
enemies will face me
now seek against me
host shall fear me
enemies encamp me
please now believe me
rise far above me
keep not secret me
hide not forsake me
answer now believe me
life came against me
believe me believe me
false host against me
stumble not fear me
secret host against me
encamp not against me
answer whom hide me
enemies shall face me
seek not forsake me
witness not hide me
fear not sacrifice me
believe me believe me
after whom forsake me
light seek after me
fear not forsake me
believe me believe me

"Genius does not have to breed:
it is its own good breeding."

—Diamanda Galás—

End of the World

Evolution of the species will be paradoxically in the hands of nonbreeders searching for immortality. Important discoveries will be made by those unable to procreate. Those unwilling to procreate will be considered extremely evil and will enjoy blasphemic repudiation by the producers of baby food and diaper industries.

There will be no room to breathe; the breeders will have destroyed us all, reduplicating their own image, that of the breeder; we will be covered in feces donated by our neighbor and will be drinking strained fecal water. We will for this reason be unable to hold our bowels and will be ceaselessly defecating in the streets and against nearby buildings.

Breeders will continue to buy more and more property in the suburbs where they can raise their squall, whose sewage pours forth from the suburbs into the cities, the dumping site. They will continue to complain about the toxic nature of the city dwellers until they are poisoned en masse one day by the pernicious shit of a little five year-old boy from Nyack, whose name will remain anonymous.

Women will have reached critical mass and will execute on sight all males whose behavior is consid-

ered disrespectful. Their disinterest in breeding will have produced a tendency towards random violence since their hormones are not being tethered to the male agenda. They will walk in packs and gun down every suspected insult; their brain stems will by now have been so finely tuned that they will even be able to predict insult before it is delivered and therefore be able to prevent the crime at its execution.

THE EXPOSED penises of unappealing and/or untalented men gyrating onstage will not be tolerated and will be removed by the female tastemakers. Male expressionism will be discouraged. All male useless emoting onstage shall be punishable by death.

ROCK AND ROLL emoters and rap emoters will be scorned and sodomized for sport on the weekends by gangs of women who are not breastfeeding on those days and have not, therefore, forsaken their military upbringing.

MORPHIC RESONATORS will continue to rule; they will finds ways to reign by constantly changing to suit the changing tastes of the masses. They will be extremely professional and heavily subsidized by the taste analyzers and will subsist for shorter and shorter periods of time as the attention span of the public has become shorter and shorter and its excretory demands are higher and occur more frequently over time.

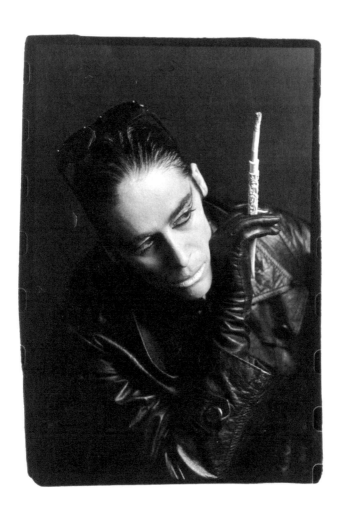

[*Photo: Beatriz Schiller*]

CRITICAL KNOWLEDGE:
THE EDUCATION OF A MUSIC CRITIC

I held that hairless brainpan down and said, *"Bitch, take it like a man."* "Oh god, stop it,": whined. I said, *"Take it bitch."* Bitch squealed, glasses and bald head, pancake ass heaving... *"Take it, peanut dick,"* I screamed, his hiney splitting in pain, sweat pouring from his anus. *"Repeat after me, Sandy,"* I yelled. *"Diamanda is a great genius, Diamanda is a great genius,"* while I cornholed flat buttocks, laughing. "Oh my god, Diamanda," he pleaded.

"Say it, say it, bitch! Give me that bald head, bitch," while I urinated in his mouth. *"Take that genius, take that elixir, bitch... take it all down. Take that godhead, Sandie. Corndog loves his mother, doesn't he?,"* I laughed, my fuck-stick thrusting. *"Can you feel it?"* Blood spurting from his anus, peanut heaved again. *"What does the good music critic say? Repeat after me... 'Diamanda is a great genius: when may I kiss her ass?'"* "Diamanda is a great genius: when may I kiss her ass?"

Yes! You've got it, literatus, polly purebred, while I split his ass and god rushed from my loins, and I vomited, and the skies opened wide, and the squiny lips of the literatus shook silently and he could suddenly hear, his piglet brain too tired to spend its time in understanding... and he could finally *HEAR* the voice of god and her angels, while the rivers of blood poured from his grateful anus. And a pregnant and magical silence descended upon us at the Death of Good Reason and Rebirth of Beauty, and then we knew that we would finally hear again.

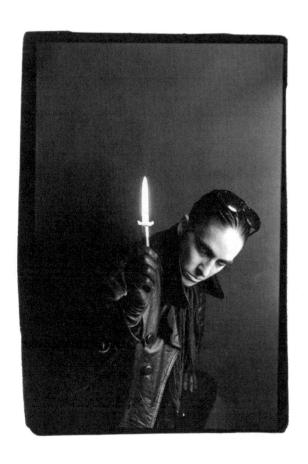

[*Photo: Stephanie Chernikowski*]

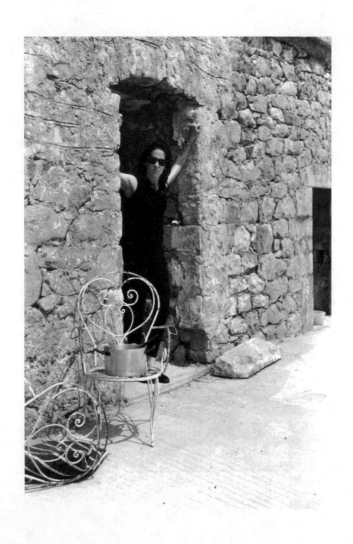

[*Photo: G. K. Galás, Mani, 1991*]